Painting in Oil

PAINTING IN OIL

A MANUAL FOR THE USE OF STUDENTS.

BY

M. LOUISE McLAUGHLIN

———

CINCINNATI:

ROBERT CLARKE & CO.

1888.

Op. IV.

COPYRIGHT, 1887,

BY

M. LOUISE MCLAUGHLIN.

PREFACE.

PAINTING in oil offers a means of artistic expression more nearly perfect than that afforded by any other method. Whatever may be the especial charms of other mediums, this must ever remain the one which gives the freest range to the capacity of the artist, and the most direct and complete facility in the representation of nature. The subject is, therefore, one of great importance from an artistic point of view, and one into the consideration of which I might hesitate to enter did I not venture to believe that some of the facts in regard to its technical aspects which will be found in the following pages, may be of use to others.

PARK AVENUE, WALNUT HILLS,
CINCINNATI, Nov. 1887.

TABLE OF CONTENTS.

INTRODUCTION.

ITHIN the last few years a great change has taken place in the methods of painting, one might almost say that this has occurred within the last decade, as it is scarcely more than ten years since the school of the Impressionists, so important a factor in the result, forced itself into public recognition. It is certainly within this time that we have been able to observe in our own country the growth of new ideas, destined to revolutionize the art of painting. Much has already been accomplished by the new school which has arisen, and in it there is much hope for the future. While some of its votaries have carried the expression of their ideas to the verge of sensational extravagance, others adding a noble technique to correct drawing,

have produced works which will lift the pictorial art to a higher plane than it has ever occupied before.

The leaven of good instruction is seen to be at work in the schools. To the students whose art education has extended over the period in which the new methods have been introduced, the change has been very perceptible, and has brought to these unfortunates great discomfiture. After having perhaps, been carefully trained by conscientious adherents of the old school, it was with dismay that they were confronted with the task of unlearning all that they had toiled to acquire through years of all but useless endeavor. Happy are those who begin their study of art under the more favorable conditions now existing.

The old system of instruction in drawing no longer prevails. The student is not now permitted to waste valuable time in copying from the flat; and the scarcely less useless practice of drawing from the antique has, in the most enlightened art schools, been degraded from its former high position in the course of training, while the more practical method of studying effects of light and shade from still life or from the living model, has taken its place in primary as well as in more advanced instruction. The pupil is taught to take a broader view of his subject, to see things in

masses of light and shade, to study the effect as a whole, rather than lose himself in a maze of incoherent detail.

In painting, the difference between the new school and the old, shows itself in the choice of a subject, which is always something that can be studied from real life—for the new school prides itself upon its realism—but still more plainly in the handling of the materials with which the painting is executed, the method or technique of the work. It is this view of the subject which is to be treated in the following pages—the materials to be used and the method of using them.

Although we do not, here, intend to enter into the consideration of the intellectual or literary side of the subject, a word to the student in regard to the choice of a motive may not be out of place. The drawing of the human figure is exceedingly difficult, so difficult that the number of living artists who have compassed all its requirements is very small. Let the beginner, therefore, hesitate before he undertakes what is beyond his powers. It is not the size nor the importance of the subject that makes the picture. It is better to paint a cabbage, and do it well, than to attempt a great historical painting and fail—the former is an artistic achievement, the latter unworthy the name of art.

That the student has acquired a certain knowledge of drawing before attempting to paint, should be a foregone conclusion. Drawing the subject is always supremely difficult, and if in addition the mind of the student is burdened with the embarrassing details of technique—the mere laying on of the color, not to mention considerations of harmony or truth to nature—the task, to one unskilled in the use of the pencil, cannot be less than impossible. Through the more simple medium of drawing in black and white, must the eye first be taught to see and the hand to represent the object seen.

The importance of beautiful and harmonious color and fine technique in a work of art, cannot be overestimated, but underlying these desirable qualities the trained hand of the skillful draughtsman must be evident or the work will be a failure from an artistic point of view. We sometimes see pictures in which the fine drawing compels admiration, although the technique may be feeble and the color fail to please, but no amount of skill in painting or beauty of color will hide defects of drawing.

If the student therefore, has compassed these preliminary requirements—we are ready to consider the material side of the subject, the tools which he should use and the best method of handling them.

PAINTING IN OIL.

CHAPTER I.

TECHNIQUE

FROM the artist's point of view, there is nothing connected with the art of painting 'of such importance as the technique or manner of laying on the color. It is the constant reproach of the critic, that this is all the artist sees in a work of art,—that the idea, the conception of the subject, in fact, the soul of the picture is nothing to him,—that he is interested simply in observing how the painter has mastered the technical details of his work.

There is perhaps too much truth in the charge, still it is difficult to overestimate the importance of this part of the subject. The idea intended to be conveyed by the picture may be most worthy of representation, the conception all

that could be desired, the drawing fine; yet if the technique, the brush-work, is feeble, the whole will have failed in its proper realization, and the work will have little artistic value.

Even the choice of the colors which are to form the palette is of less consequence than a knowledge of the best way to use them, for the secret of clear and brilliant coloring is not found in the resources of the color-box, but in the skill with which the pigments are laid upon the canvas. The artist who has mastered technique can paint with almost any thing. It has been said of a well-known painter, that from the palette of a brother artist laid aside after a day's work, with tints apparently hopelessly commingled, he could paint a figure exquisitely fresh and dainty in color. Certainly, a proof of no mean skill, yet an illustration of the fact that in this as in other arts, it is not the excellence or variety of the material at command which counts, but the ability to use it to the best advantage.

We often hear students ask what colors were used to produce certain effects, as if every thing depended upon the answer. The artist of whom the question is asked seldom knows how to answer it intelligently. He has ''felt around,'' perhaps, until he got it. It would be better, doubtless, if the painter were able to tell exactly what colors he used,

and what means he employed to arrive at the effect in question; yet to one who understands any thing of the infinite variations which can be produced by the mixing of colors, it is not surprising that he should be unable to do so, nor would the mere knowledge of the names of the particular colors made use of enable the scholar to imitate it. Lists of colors by which certain tints can be produced may afford valuable suggestions to the student capable of profiting by them, but it will no more render it possible for one who does not know how to use them, to paint. a picture, than would the possession of a dictionary enable him to write a book.

This most important work, therefore, the acquisition of the skill which will enable him to use his tools to the greatest advantage, must be the aim of every artist, and the object to which his unremitting energies are directed. He must master his materials, not be mastered by them. This end is only to be attained by practice, and practice, moreover, guided by right principles.

Some suggestions can be given which may aid the student desirous of attaining a good technique. Of these the most important is, that no stroke of the brush should be laid upon the canvas except with the intention of producing a certain desired effect. There must be no

experimenting, no feeble dabbling or "feeling around" to get the right color or tone. The trouble with many students is that they work without thinking. To paint is not an easy task. To represent nature pictorially, by means of the limited resources at the command of the artist, requires the best efforts of the human intelligence brought to bear upon it. A certain amount of manual dexterity is required, but it must not be forgotten that the work is done in the brain, and that the excellence of the result will be in direct proportion to the amount of thought which has been bestowed upon it. The subject should be so carefully studied that there is a well-formed idea as to the manner of its representation in the mind of the artist, and then each touch should be deliberately planned and separately applied as a means to a definite end.

This leads to a consideration of the more purely technical aspects of the subject. It is to be supposed that the student of painting has acquired some knowledge of the art of seeing things as they should be represented pictorially, as this study is a necessary preparation for the practice of art in all its branches, and not alone in the one we are now considering. It is in this branch of art, however, that it has its best exemplification. By the art of seeing things as they should be

represented pictorially, we mean the method of looking at natural objects, as masses of light and shade, or in painting as formed of patches of color which, when represented in their proper relations to each other and to the whole, give an effect of roundness and solidity. The method of the modern painters has been called "*la tache*," referring to the manner in which the tints are laid on in touches or patches of color like the separate pieces of a mosaic. The gain in force and brilliancy by this method of working is immense. In the old method by which the tints were worked into each other by an insensible gradation and, perhaps, afterward united with the aid of a blending brush, the whole became an inane, painty smear, in which the shortcomings of the pigments as a means of representing the light and color of nature were painfully shown. If in the work of some of the modern impressionists, accuracy of drawing and truth of tone are sometimes apt to be sacrificed to the exigencies of the method, there is a great gain in vigor and brilliancy of effect. The best technique will be found in a happy mean between the two extremes. It should not call attention to itself by its feebleness, nor on the other hand by its evident striving for effect.

In regard to the preparing of tints, it may be unnecessary

to say that the practice of mixing the colors with the palette knife and thus setting a palette preparatory to beginning work with the brush, is obsolete. The colors are to be placed upon the palette and mixed only with the brush, and if when applied to the canvas they are yet so imperfectly blended that the tint appears when closely examined to be made up of minute threads of various colors, the effect will be much more brilliant than if it were so mixed as to form one homogeneous tone. Specks of pure color placed side by side react upon each other in such a way as to produce the effect of combination, yet appear much more brilliant than if actually combined.

The colors must be mixed as little as possible, and never overworked. There is an almost irresistible temptation for the beginner to go over the work in the attempt to improve it, but an indulgence in this habit will result disastrously on the brilliancy of the colors as well as upon the technique. If it will not come right, it would be better to scrape the paint off and begin again than to risk sullying the colors by overworking. The difficulty of representing nature with the facilities we have is great enough without wasting any of the force at our command. The only safe plan is to find out what you want to do before beginning, carefully to consider

e model, studying the tone you wish to produce in its re-
tion to the other tones of the picture, and after having
xperimented on your palette as to the combination of colors
hich will produce it, then and not until then attempt to
y it upon the canvas.

Do not lay a second touch without going back to your
alette to replenish your brush with the color necessary
or the next tone. Remember also, that if you can repre-
ent the subject with a few strokes, the result will be so
uch the better.

Cultivate a broad style by using a brush as large as can
e conveniently adapted to the size of the painting, and
ndeavor to attain a firm and decided touch. The direction
f the strokes of the brush should follow the form of the
bject represented. In painting flesh, for instance, the
trokes should follow the rounded form of the muscles, or in
rapery they should pass across the folds instead of length-
ise. This method of working adds vastly to the effect of
oundness and solidity.

In some cases, as in the more retiring parts of a picture,
t is not always desirable that the brush marks should show.
A smooth surface can be procured when desired by allow-
ng the paint to dry thoroughly and then rubbing it down

with cuttle-fish bone. Water can be allowed to run over the
canvas, which is held carefully so as to avoid scratching the
surface to be rubbed with the sharp edge of the bone.
The hard edges of the bone should be broken off before
using it, leaving only the friable inner portion, which, if
properly used, can do no injury to the painting.

In cases when it is desirable to avoid brush marks for the
sake of brilliancy of effect, as in the representation of a white
object illuminated by the sun, the palette knife is a valuable
implement. The strokes of the brush, even when not very
obvious, still present a surface which catches the light in
such a way as to lower the tone slightly, the projecting parts
casting slight shadows. With the aid of the palette knife,
however, a touch may be made so smooth that it will per-
fectly reflect the light and produce an effect of as great
brilliancy as it is possible to give with paint.

The palette knife will indeed be found most valuable
wherever it is possible to use it. With its use effects can
be produced, which are unapproachable by any other means.
In the representation of a clear sky, or one in which the
clouds have no decided form—a hazy effect of cirrus clouds—
in painting a road, or water, either smooth or ruffled by the
wind, and in back grounds, the palette knife is most useful.

Methods like this, of using other implements besides the brush, need not be considered as tricks. Any practice or method which tends toward a better representation of nature by means of pigments is legitimate, from an artistic point of view. It is only when this liberty is transcended, where a painter seeks to add to the effectiveness of parts of his picture by modelling them so as to give an actual relief, or when foreign materials are introduced, where the old paint-ers used gems, or as in the case of a certain modern artist who employed metal as an adjunct; that the painter over-leaps the bounds of realism and trespasses upon the do-main of the decorative artist.

Although the use of the palette knife may have been abused by some, and it can readily be seen that it is not an implement that admits of universal application, yet, wher-ever practicable, it affords the most simple and direct means of attaining the effect desired. And in painting it may most certainly be affirmed, that, as a rule, the result is good in exact proportion to the simplicity of the means by which it was attained.

The question as to the impasto, or thickness of the body of color used upon the canvas, is sometimes a matter of embarrassment to the student. There seems to be, among

persons uneducated in art matters, a deeply rooted objection
to painting which shows the marks of the artist's handling
in roughened inequalities upon its surface, and the story of
the committee who chose pictures for an exhibition by clos-
ing their eyes and passing their fingers over the surfaces to
find which were the smoothest, is, unfortunately, not so im-
probable as to be regarded altogether in the light of a mere
humorous invention.

Now this question of a thick or thin impasto is one which
has in itself no direct relation to the excellence of a work
of art, and one which in the case of the artist must receive
its solution according to the exigencies of the work in hand.
He sets himself the task of reproducing a certain effect; if
in some places the paint is laid on so heavily that it stands
out in relief and in others so thinly that the canvas shows
through, it is no matter so long as the effect is what he
desired to produce.

In the light of new ideas it seems hardly necessary to
mention certain methods formerly in vogue, but as there are
still teachers who practice, and students who are hampered
by them, it may be well to refer to them. Perhaps the
student may have been puzzled by the terms "body color"
and "dead coloring" as employed by teachers and writers

of the old school. Under such instruction he was recom-
mended to paint the subject in monochrome, then lay in the
"dead coloring," and finally in the after-painting finish what
would by that time, in all probability, be a mass of paint
with which it would be impossible to do anything. If you
are going to paint anything from nature, the effects you
desire to produce will be of such an evanescent character
that they must be caught at once, and painted as they
appear, without going through the process of making an out-
line, a sketch of light and shade, laying in "dead color,"
&c. Your aim should be, to observe correctly the charac-
teristics of the subject, the color and tone in relation to its
surroundings, and to represent it, with the aid of the pig-
ments, as simply and directly as possible, laying each tint in
its place and leaving it. If you should be so fortunate as to
get it right or so nearly so as to satisfy yourself the first time,
so much the better.

Use the pigments thickly enough to give the necessary
appearance of roundness and solidity. The canvas upon
which your picture is painted is not to be considered as the
side of a house upon which so many coats of paint are to be
laid, but simply as a base or surface upon which you are to
bring out your picture. The materials of which your paint-

ing is composed are to be kept, as far as possible, from being obtrusive. The paint does not make the picture, it is simply the medium by which your ideas are expressed, and a safe rule to follow would be to use no more of it than you know what to do with. In the proper place and used with intention you can hardly lay it on too thickly, but a mass of paint laid on without any meaning becomes only so much matter in the wrong place.

In the finest technique the impasto is thick, the tones clear and the whole effect strong and realistic, but the material by which this effect was produced is kept in such subservience to the intention of the whole that it may be difficult at first to discover the means by which the result was attained, for here, as elsewhere, the highest art consists in the conceal-ment of art.

CHAPTER II.

T HE power of producing harmonious color in art seems to be largely due to a natural gift. The colorist, as the poet, is born, not made. Yet, while we are forced to believe this, we can not doubt that, to a certain degree, the color-sense can be cultivated. The present state of our knowledge, however, hardly affords us the means of estimating the degree to which the cultivation of this faculty could be carried.

Children very early display an appreciation of color. What might be accomplished were any systematic efforts made to educate this taste we do not know, for the child, instead of being surrounded by examples of the harmonious arrangement of color, and made the subject of careful instruc-

(21)

tion in its mysteries, is usually brought into contact with colors and combinations the reverse of instructive, and made the victim of the crude ideas so generally prevalent upon the subject. When we consider the influence of the more intimate surroundings, there is little cause to wonder that the object lessons of nature lose much of their force, and that the child grows up lacking in greater or less degree the power of seeing color.

As there are innumerable physical variations in the organs of sight as well as differences in the perceptive faculties, so there are all degrees in the manifestation of the sense of color, from the condition known as color-blindness to the power of recognizing the subtlest harmonies of tint. One who possesses the faculty of perceiving color harmonies, and consequently suffers annoyance when these harmonies are disregarded, has only to look around him to become painfully aware of the rarity of any proper conception of beauty or fitness in the use of color. That much might be done by education to improve the general taste in this respect scarcely admits of a doubt. It is true, education can never carry the individual beyond the limits of his own peculiar organism, and it can not render the eye physically incapable of distinguishing color, or the brain blind to such perception, re-

sponsive to its harmonies, yet it is certain that with people in general the color-sense might be brought to a much higher degree of development than it has reached. The fact that the defect of vision known as color-blindness is comparatively rare among women would seem to indicate that the educa-‘tion which they receive from the associations and occupa‚ tions which lead them to pay more attention to color, and constantly to practice its combinations for decorative effect, has an influence even over natural tendencies. It at any rate goes to show that the faculty of color perception is sub-ject to the same rules which govern other faculties, and is strengthened and perfected by exercise.

A theory was advanced not long ago by Dr. Magnus, in which it was suggested that the perception of color in the human race had been developed during the last four or five thousand years. The theory was supported by Mr. Glad-stone and others, who believed that they had discovered corroborative evidence in ancient writings. The lack of definiteness in the phraseology descriptive of color was taken as an indication of the failure to perceive the less ob-vious differences of hue. This may, however, have re-sulted from deficiencies in the languages rather than from any want of color perception, and as has been pointed

out,* similar peculiarities might be noticed in the writings of the present day. In modern poetry references to red and yellow, and terms descriptive of such color sensations are much more frequent than those relating to the less striking colors. There is still sufficient vagueness in the terms used to express color sensation, both in writing and speaking, to cause us to hesitate before accepting a theory on such grounds. Moreover, nations of a low degree of development at the present day do not exhibit any deficiency in the faculty of distinguishing color, and an apparent sense of color has even been observed in the lower orders of animals.

The analogies of evolution suggest the probability that the perception of color as it now exists in the human race is the result of a gradual development extending over a very long period of time, but there is no sufficient evidence to prove that there has been any change in the color-sense within historic times; yet, while we are not able to see more *colors* than the ancients, it is probable that there has been an improvement in the perception of color *harmonics*.

The phenomena of sound can not be reconciled in all particulars with those connected with vision, and therefore the analogies drawn between them, so frequently attempted, are

* Grant Allen in " The Development of the Colour-Sense."

likely to be misleading, but the fact that there has been a development in the perception of musical harmonies would suggest the possibility of a similar advance in color perception, although it is by no means so apparent or so widely extended as it should be.

It may be urged in opposition to the idea that there has been an improvement in the perception of color harmonies that much of the old decorative work is superior to that of modern times, also, that in the work of savages, what appears to be a very fine sense of harmony of color is frequently exhibited. This apparent superiority may, however, in the old work be merely the result of the softening influences of time, while in the case of the savages, it may be due not so much to a perception of color harmonies as to the paucity of materials and the imperfections of the rudely manufactured colors which these people are obliged to use, for it may be noticed that when savages are furnished with the hideously crude and brilliant dyes of civilization, they use them with such an utter disregard of harmony that their work becomes artistically valueless. When limited to a few simple dyes, dull, because imperfectly prepared, and harmonious because derived directly from nature, their work is pleasing to the most cultivated eye. But give them the gorgeous tints that the

modern chemist has evoked, like evil genii, from the un-
promising coal-tar, and they will make as many mistakes in
the combination of color as the most Philistine of our own
carpet designers. The lamentable effects upon the work of
the American Indians, upon the products of the Persian rug
makers, even upon the art of the very clever and highly
civilized Japanese and, indeed, on that of all people upon
whom the corrupting influences of European civilization in
the matter of modern dyes and pigments have been brought
to bear, are too well known to be ignored. What a com-
mentary upon our present state of advancement in this direc-
tion, when it is evident that we can not even instruct savages
in the use of color, and also that our boasted civilization has
injured the art of nations which we consider below us in the
scale of development.

That there has been an advance in these matters, how-
ever, can be seen when we read descriptions of costumes
worn even as late as the seventeenth century, and in the
magnificent court of Louis XIV., where even the lavish use
of gold and silver and the richness of the materials could
hardly have made the combination of blue, crimson, purple,
and green in one costume, tolerable to even ordinarily culti-
vated eyes of the present day. Specimens of the stuffs used

in those days which have come down to us, frequently ex-
hibit such crude colors that even the lapse of time has failed
to render them agreeable. The introduction of the brilliant
aniline dyes some years ago retarded the progress of im-
provement in the use of color, and it is only within the last
few years that a marked change for the better has been ob-
served. This improvement is seen in the manufacture of
all kinds of material for decorative purposes, that can now
be procured of very beautiful colors, in great contrast to the
crude tints exhibited not long ago. Let us hope that these
effects are something more than the ebb and flow of the
tide of fashion, and may result in a permanent advance.
Much has already been done toward educating the color
perceptions of the people, but much yet remains to be ac-
complished, and there is still abundant room for improve-
ment in decorative art as well as in the art we are now con-
sidering.

The difficulty is not the lack of pigments with which to
produce beautiful color. On the contrary, we suffer rather
from an embarassment of riches in this respect, and, like the
savages, are overwhelmed by our too extensive palette.
We do not want more colors or brighter tints, but we need
to know how to use those we have to the best advantage,

and to practice in our limited field something of the reserve and economy of nature. The more brilliant colors are seldom seen in Nature, and then only in small quantities; she husbands her resources of color only to introduce them with the most telling effect. The outside world is a harmony of blues, greens, browns, and grays, only occasionally showing the brighter colors in the gorgeous tints of the sunset or the dashes of brilliant color in flowers, or the bright plumage of birds.

Although we are obliged to use colors infinitely less luminous than those of nature, the tendency in painting is rather to err on the side of too great brilliancy — a too lavish use of color. While endeavoring to imitate the clear brightness of nature's tones, the painter too frequently makes use of pigments which, instead of producing the desired effect, give an appearance of harshness and crudity. Bright colors should be considered as precious jewels, used only to accentuate some part of the composition, so carefully disposed as to their setting and so sparingly displayed, that their natural brilliancy is enhanced, while they do not interfere with the harmony of the whole.

Study of nature's methods will show that it is not in brilliant or striking effects that the most pleasing results are to

be found, but in tender and low-toned harmonies where the transition from one color to another is so artfully arranged as to be scarcely perceptible to the uninitiated eye. If sometimes the artist desires to produce a strong impression, a *tour de force*, it must be remembered that he undertakes a task from which only genius can issue triumphantly, and that the part of prudence is to avoid the difficulties of combining many or widely differing hues.

The production of harmonious combinations of color in art is after all so much a matter of feeling that it is difficult to give any instruction in the matter. It does not seem possible ever to govern the use of color by rules; yet, while no amount of theoretical knowledge can make a colorist, the artist should use every means of adding to his knowledge of this most important subject. The science of color is as yet but imperfectly understood, but much has been done in this direction in recent years, and some interesting discoveries have been made in regard to its nature. As we may gain some valuable suggestions from these researches, it may not be out of place to refer to them here. In order, however, that what follows in regard to color may be understood, it may be necessary to state the theory of light as

now held by the scientific world, as the phenomena of light and color are most intimately associated.

All bodies not themselves luminous become visible by light thrown upon them from some luminous body and reflected from their surfaces. In the ordinary light of day, objects are seen illuminated by the rays of the sun. According to the theory now held, these rays are communicated by a wave-like motion through the mysterious medium, or ether, which fills all space. This motion is one of inconceivable velocity, and it is to this extreme velocity of the light waves that we owe our power of seeing color. The mean wave length of the rays has been estimated as only one fifty-thousandth part of an inch. The rays which, when interrupted or completely reflected from the surface of any object, produce upon our eyes the sensation of light, do not all exhibit a similar vibration. On the contrary, the motion of the different rays varies to such a degree as to be apparent to our sense of vision. This compound character of light can be demonstrated by allowing a beam of sunlight to pass through a prism which decomposes it, and allows us to observe the sensations produced upon our eyes by the different wave motions of its component parts.

We have then, from the decomposition of light, what is

called the solar spectrum, the series of colors which are seen in the rainbow (a spectrum produced by natural causes), beginning with red and ranging through the various hues of orange, yellow, green, blue, and violet. Objects vary in their manner of receiving and reflecting light, and according to their peculiar qualities they absorb or destroy certain rays which come in contact with their surfaces, and throw off others. The color of an object depends upon the character of the rays which are reflected or thrown off from its surface. Thus, when all the rays are reflected, the result is that absence of color which we call white, or undecomposed light. In other cases rays of various wave lengths are reflected, giving us the sensation of seeing objects of different colors. For instance, any thing which appears green has the quality of absorbing all the rays except the green ones, which are reflected from its surface in such a way as to render it visible as as a green object. If all the rays are absorbed, we are aware of a lack of color and luminosity which we call black. The cause of these effects is, therefore, this mechanical motion of light which, when translated by the sensations produced upon our eyes, becomes to us color. In what manner

these sensations are produced upon the eye, is as yet not fully understood.

According to the theory formerly held, there were three primary colors, from the combination of which all others were produced. These colors were *red*, *yellow*, and *blue*, and were said to be represented most nearly by the pigments Rose Madder, Aureolin, and Cobalt. This theory was founded upon the results obtained from the mixture of pigments and from combinations of transmitted colored light. While true in regard to pigments, and therefore of practical value to artists, more recent experiments have demonstrated that in the case of *colors* apart from *pigments*, the theory is entirely false. The theory of Dr. Young in regard to primary colors, advanced early in the present century, but more recently developed through the labors of Helmholtz and Clerk Maxwell, is the one now generally received.

According to the present theories, we are only cognizant of color through the sensations produced upon our eyes. There is no color, then, apart from us and our perceptions, and it can not be said that, in an objective sense, there exist three primary colors. The demonstrators of the new theory have proved by experiment, however, that the hu-

man eye is subject to certain primary or fundamental color
sensations. In this sense, therefore, certain colors may be
considered primary. Prof. Clerk Maxwell called *red*, *green*,
and *blue* the three primary colors, and considered the pig-
ments Scarlet-Vermilion, Emerald-Green and Brilliant-Arti-
ficial-Ultramarine to represent them most nearly.

A still more recent theory was that proposed by Hering,
who believed the sensation of color to be produced not, as,
the others held, by stimulation of different sets of nerves,
but by the action of light upon certain visual substances in
the retina. These substances are acted upon in an opposite
manner by each of the following kinds of light, viz. :

> Black and White,
> Red and Green,
> Blue and Yellow.

These would therefore be the contrasting or complement-
ary colors, and form the fundamental color sensations.
Foundation for this theory of sensation produced, upon a
visual substance, is given by the discovery of a purplish-red
substance in the retina, which quickly changes and disappears
when it is removed from the eye and exposed to the light.
Boll and Kühne have studied the effects of colored light
upon this substance, and have constructed a theory of vis-

ion from the results of their experiments. It is to the effect that the action of light upon the retina, produces certain compounds, varying according to its differing vibrations, and so gives rise to the sensations of color. The fact that there is a constant renewal of the part of the eye in which these visual substances are supposed to be located, seems to favor this theory. The retina, with its visual substances, might be compared to the sensitive plate in the camera, which receives impressions from the chemical action of light. But the processes by which light acts upon the eye have not as yet been fully explained, and the whole matter is in an indeterminate state. We only know what most immediately concerns us—that light gives us, according to the varying vibrations of its rays, certain sensations which we recognize as color.

The red rays have the slowest vibration, and produce the most vivid sensation upon our eyes. The orange, yellow, green, blue, and violet rays have an increasing velocity of motion to the point where our vision fails to take cognizance of further variation. Beyond the violet rays, we are as yet unable to recognize the action of light except by its chemical properties; and, on the other hand, we can not

perceive any thing beyond the red rays except by the sensation of heat.

It is, then, to this division of light into its component parts according to the nature of the object from whose surface it is reflected that we owe all the varied hues about us. As a matter of fact, no natural object reflects rays of one kind only, as the rays which are chiefly reflected, and therefore give the dominating color, are so mingled with others as to modify the effect and prevent the color from being pure. It is this quality which affects the mixture of pigments, and which, as has since been proved, rendered the former experiments in regard to the establishment of the theory of primary colors, of no value. For instance, the fact that green could be produced by a mixture of blue and yellow, was considered one of the strongest proofs of the old theory, and was supposed to militate against the statement that green was a primary or fundamental color. Admitting the fact that the mixture of blue and yellow pigments will produce green, it by no means follows that the combination of blue and yellow *colors* will produce green. The result in the mixture of pigments can be accounted for by the fact mentioned above, that no natural color is pure, but reflects, along with the rays which give it its general

hue, other rays which have a wave motion of nearly the same length. Thus a blue pigment, while giving the general effect of this color, will have mixed with it some rays of colors contiguous to it in the spectrum—green on the one side, and violet on the other. A yellow pigment, on the other hand, will transmit with its principal color rays of the orange, which resembles it, on one side, and the green nearest in wave length on the other. Thus the one color transmitted in common by both, in combination with their own proper colors, is green, and this color is therefore the result of a union of the two pigments. The production of the color green is therefore due to the impurity of the pigments. It is, perhaps, fortunate for the practical purposes of the artist that the pigments are not pure in color.

There is also in the mixture of two pigments a loss of luminosity, because the resulting color is not the sum of the reflective action of both, but consists only of the rays that both are able to transmit after having absorbed all the others. If both pigments were pure, the result of the mixture would resemble that which comes from the mingling of two complementary *colors*, or white. The recent experiments have been made, not with pigments or transmitted

colored light, from which the colors would in either case be more or less impure, but with the pure colors of the spectrum, which show entirely different results.

The experiments with the spectrum are somewhat complicated, but there is another method by which any one can test the truth of the new theory in regard to the mixing of colors. The method is as old as the time of Ptolemy, but it was perfected by the late Clerk Maxwell. Disks colored in the proper proportions with the two colors which are to be combined are caused to rotate rapidly. The rapidity of the revolution presents the two colors in such quick succession as to give the impression of the two combined or superimposed upon the retina. This gives the true mixture of the colored light reflected from both pigments, and, therefore, the combination of the *colors*. In the case of yellow and blue, the result is not green, but as nearly white as the purity and luminosity of the pigments will permit—usually a light gray, which is the same as white seen under a low degree of illumination. There are many interesting experiments which can thus be made in the mixing of colors, and, while it is unnecessary for the artist to enter into the subject in the manner of the scientist, much practical benefit may be derived from these studies.

In the previous chapter, reference was made to the fact
that colors appear much more brilliant when only partially
mixed, or when laid on by the brush or palette knife in such
a way that the tint, when closely examined, appears to be
composed of mingled threads of color. The scientific ex-
planation of this effect has been suggested in the reason
which has been given for the loss of luminosity when
pigments are mixed. When the different colors are laid
side by side in minute lines or points, the effect which
reaches the eye of the observer at the proper distance is
that of the commingling of the colored *light* reflected from
the pigments, without the loss of luminosity, which would
have resulted had they been actually combined. While by
this method the most brilliant effects can be produced, there
is in it, also, an analogy to Nature's way of producing color
combinations, as she constantly presents us with arrange-
ments, which, upon close examination, are found to be
made up of minute patches of various hues.

Even in the case of single objects, or surfaces, there is no
equality of tint in nature. The artist should remember that,
scientifically speaking, there is no such thing as "local
color." What seems to be the general hue of the objects
about him, is only the play of light upon their surfaces,

infinitely varied at every turn. In painting them, no color should be laid on as "local color," but every touch must go to make up a mosaic, each part of which differs from the rest, but which, when viewed at the proper distance, will produce an effect which the observer may not be able to analyze, but which will give an impression of harmony of color and richness of tone which can be produced in no other way.

This method of working, where each separate touch is considered and applied in its proper relation to the whole, (already described in the chapter on Technique,) is of equal value in the matter of color. It is in this way that the tones of nature are produced, and in this way only can we seek to imitate them. The ordinary observer may note and admire these effects of color, and may be conscious of a lack of harmony, where, in a work of art, the means of producing them have been neglected, but it is the task of the artist to analyze the tones, and as the skilled musician distinguishes the different notes in a strain of music, or the quality of the various instruments in an orchestra, so the artist, while appreciating the beauties of nature to the fullest extent, must essay the difficult task of discovering how these effects are produced. He must not be too much influenced by what he knows to

be the color of the object he is painting, for, as has been
suggested, the color is, after all, only the effect translated
by his eyes as the result of the combined influences of light,
shade and reflection at work upon it. He must not be
afraid, therefore, to represent things as he sees them, but
even to see them properly, he must abandon any pre-con-
ceived notions, as to how they should appear. The artist,
as the scientist, must go to Nature in childlike simplicity of
purpose and be ready to modify his ideas of things as she
dictates. He must, however, exercise his judgment to de-
termine what is best suited for representation. As it is not
everything in nature which is either desirable or proper for
his use, so it is not every combination of color which will
look well in a picture, and he must cultivate a habit of close
observation, which will enable him to see beauties unre-
vealed to other eyes, and yet, among the subjects so lav-
ishly displayed around him, to choose only those which are
most worthy of representation.

While there must always be differences of opinion as to
harmony of color, while the combination which to one
appears perfect, may to the differently constituted visual
organs of another, be less pleasing, yet we cannot but think
some guide in the mazes of this much disputed question

may be found, which will lead the student to a better under-
standing of its mysteries. There is, of course, as in all
other matters of taste, an appeal to the usage of those who
are by common consent acknowledged to be the best
authorities. The study of the works of those masters to
whom critics have awarded the palm as colorists, cannot fail
to be most instructive to the student, yet he must in this,
as in all other branches of his art, cultivate the habit of
thinking for himself, and must strive to discover the secret
which underlies all.

The difficulties of harmonizing color, great enough where
the whole composition is low in tone, are vastly increased
where brilliant and very dissimilar colors are introduced.
Contrast has been considered necessary to harmony, and it
has also been laid down as a law, that no combination of
color could be perfect unless it embraced the three primary
colors (as then denominated,) red, yellow and blue. Field
even went so far as to formulate a rule for the proportions
in which these three elements should enter into a perfect
composition. The absurdity of such rules, founded, as they
were, on a false idea of the fundamental elements of color,
can easily be shown, and while, as has been said, it seems
impossible to reduce the formation of agreeable combina-

tions of color to rule, there are certain general ideas upon
the matter which the student would do well to remember.

The complementary colors, those which form contrasts to
each other as given by Prof. Rood,* are as follows:

<div style="text-align:center">

Red—Green Blue ; †

Orange—Cyan Blue ; ‡

Yellow—Ultramarine Blue ;

Greenish Yellow—Violet ;

Green—Purple.

</div>

Now these colors, while mutually affecting each other to the
best advantage, do not form the most agreeable combina-
tions in art. The colors thus brought into juxtaposition
have their individual beauty enhanced; but the idea that
such contrast produced harmony, has had the most perni-
cious influence upon art. It may be objected, that just such
striking contrasts are seen in nature, and it can not be de-
nied that in flowering plants these arrangements of color
are frequently seen. The exquisitely beautiful textures of
such natural objects, as well as the variety of tone intro-
duced in the different parts, go far toward making the con-

* Text-Book of Color, International Scientific Series.

† Hemholtz gives blue green.

‡ Cyan blue is the color which, in the spectrum, comes between blue green and blue.

trasts agreeable, which, when copied in the coarser material of paint, produce a very different effect. This intense brilliancy, however, as has been so elaborately presented in the works of Mr. Darwin and others, may be but the provision of nature which renders the plant depending for its fertilization upon insects, the more attractive to the color sense which these creatures seem to possess, and so furthers the ends of its being. Nature, perhaps, uses these means in a utilitarian way, and we need not consider them examples to be blindly followed in art. Some of the most brilliant colors and striking contrasts are, also, those which have been produced by the art of the gardener, and are, moreover, placed amid artificial surroundings, where the effect is quite different from what it would have been in the original condition of the plants.

The most pleasing arrangements of color come, not from contrasts, but from similarity of hue. The adherents of the theory of harmony by contrast give a scientific explanation of the pleasurable sensation they believe to be derived from such arrangements, viz: that the nerves susceptible to the different color sensations, are in such cases equally stimulated. But without entering into the physiological, and keeping only to the artistic side of the question, we will

find that the most agreeable effects of color are those ar-
rangements where there is variety enough to avoid monot-
ony, yet with an absence of abrupt transitions. In a sin-
gle effect of color viewed as a whole, that which presents
no striking contrasts will be found the most agreeable to
the cultivated eye, while the less cultivated one, although it
may be unable to analyze the sensation, cannot fail to ap-
preciate the pleasing effect.

When anything approaching a contrast is introduced into
a composition, the method of nature must be imitated.
There must be a succession of intermediate tones leading
up to it. Nature constantly practices these effects in the
use of what has been called the "small interval," the
change from one color to another by almost insensible de-
grees. It will generally be found that the best combina-
tions come from the use of colors near each other on the
chromatic scale. Thus the warm colors harmonize best
with each other, and the colder colors can be combined,
but it is very difficult to produce a harmonious composition
which introduces both the warm and the cold colors. Com-
binations of the warm colors are generally more pleasing,
as the impression of brilliancy and luminosity is agreeable,
while an arrangement of cold colors produces a depressing

sensation. If two colors far apart from each other in the
chromatic scale are used together, they must be brought
nearer each other in tone. Both must be made very dark
or both correspondingly light, or they must be separated by
some combination of the intervening colors, which will
gradually lead up to the more brilliant one. The combina-
tion of red and blue, so frequently seen in decorative art,
is one of very unlike colors, yet it can be made a beautiful
one, if both colors are sufficiently degraded in hue. The
combination of indigo blue and a dull brick red, into which
yellow enters, is agreeably shown in some Persian rugs, yet
the most pleasing effect of this combination is produced
when gold is added, as in the beautiful Moorish decorations.
We have, then, the colors, red and blue, far removed from
each other in the spectrum, but separated in the design by
the greenish yellow which should come between them. It
is easier to produce agreeable combinations in decorative art
where metallic colors can be introduced, but in pictures
where no such relieving adjuncts can be used, the painter
must be still more careful in his choice of colors.

It is extremely difficult to produce a good effect where
there is an excess of green, the central color of the spec-
trum, in the composition. This is felt by artists in repre-

senting landscape effects in midsummer, when the greens of
the foliage are of such an intense character. This difficulty
has been explained by the supposition that as this color pro-
duces a more lasting impression upon the eye than the
others, therefore the nerves susceptible to it are sooner
exhausted. The difficulty of managing a composition in-
troducing this color in excess may, however, arise only from
its essential coldness. Also, the fact that some of the pig-
ments of this class, used by artists, as for instance emerald
green, are so bright as to be out of harmony with nature's
tones, may have something to do with the disagreeable
effect produced in many pictures. It is here that the beauty
of nature's method becomes more apparent. We constantly
see such seemingly impossible combinations of color so
arranged as to produce the most perfect harmony. The
green of the trees is formed of a myriad tints, warm and
cold, light and dark, so graduated and blended as to har-
monize with the blue of the sky, which is not pure blue,
but a tint so varied by the changing effects of light and
covered by clouds of different hues that the colors are not
decidedly contrasted, but brought into harmony by an in-
sensible gradation of tones. It is in the school of Nature
that the artist will find his best instruction and his surest

inspiration, and it is only by study of her effects, her broken
tints, her avoidance of abrupt transitions, her careful use of
material that he may penetrate a little deeper into her
secrets while imitating her modes of treatment the more
carefully because obliged to work within an infinitely
narrower range.

CHAPTER III.

S we are here concerned only with painting, the consideration of light and shade apart from color, is beyond the limits of our subject. We have seen, however, that color is only decomposed light, and, in painting as well as in nature, color and light are so closely united as hardly to be dissociated. There are certain aspects in which color can be considered as an auxiliary to the expression of light in painting, which may properly find place here. The painter has need to understand the use of all such aids, as the task of representing nature, in all her brilliancy of light and color with the aid of a few imperfect pigments, is appalling when one considers its magnitude. Compared to the dazzling effect of

(48)

a white object, illuminated by the rays of the sun, the whitest
of white paint presents but a dull and sombre tint of grey,
while on the other hand the densest black pigment would
fall far short of representing the gloom of a dark night. It
is, then, upon a very limited scale, that we must measure
the luminous tones of nature, and in representing them so
economize our material that the vast difference may not be
too obvious. Working within the bounds of this narrow
scale, there can be no absolute truth in the counterfeit pre-
sentment, there must be exaggeration here, reduction there,
yet while the whole is very much lower in tone, a great
degree of luminosity, as well as much apparent truth to
nature, can be produced by the artful management of the
scheme of light and shade which forms the picture.

The object of the painter is to produce the same impres-
sion upon the eye of the spectator as would be produced
by the natural objects in the same circumstances as those
represented in the picture. Considering the vast difference
between the scale of nature's tones and that to which
the artist is limited, this result would seem an impossible
achievement, yet there are certain conditions which favor
the artist and render it possible for him to reproduce the
effects desired with very fair success. He cannot, in the

nature of things, produce a counterpart of the scheme of
light and shade which would exist in the real objects which
he wishes to represent, but it is within his power to pro-
duce upon the eye of the observer an impression similar to
that which would be produced by the natural scene. To
do this he must exercise the most careful judgment in re-
gard to his choice of subject, and also practice the greatest
art in the arrangement of his tones.

In regard to the impression which must be produced upon
the eye of the observer, he is aided by certain physiological
conditions of the eye. The comparative sensitiveness of
the eye to degrees of light has been made the subject of
experiment by Helmholtz, Fechner, and others. A law
has been discovered by Fechner for the scale of sensitive-
ness to light, which is to the effect, that within certain
wide limits, differences of light produce an equal sensation,
if they form an equal part of the whole quantity of light
compared. Differences in intensity of light which can be
recognized under a high degree of illumination, can also be
perceived in the same relative degree when the illumination
is not so great.

Hence, although the work of the painter is executed
with pigments which reflect a comparatively small quantity

of light, and, moreover, are to be viewed under a much feebler illumination than the natural scene, as must be the case even in the best lighted gallery, he can yet, by carefully preserving the relative value of his lights and shadows, produce upon the eye of the observer the desired impression.

This rule for the sensibility of the eye only holds good for a certain mean degree of light. For extremes of light or shade the eye loses its sensibility to a certain extent. When viewing anything under a very brilliant illumination it becomes dazzled by the unusual strain, and its sensibility is somewhat deadened, causing it to fail to respond to the finer differences of light in the more highly illuminated parts. On the other hand under a very feeble illumination it is insensible to faint differences in the deepest shadows. For this reason very bright objects appear to be equally bright, even when there exist decided variations in tone, and, on the contrary, when anything is viewed under very feeble light, the eye is incapable of appreciating a very slight increase of shadow. The artist, therefore, when attempting the representation of bright sunshine, can produce the effect which dazzles the eyes of the spectator upon viewing the natural scene so illuminated, by making the objects in the brightest light almost equal in tone, and can

also heighten the effect by exaggerating the depth of the
shadows. When he desires to represent a scene under very
feeble illumination, while he has no pigments, which will
accurately represent the absence of light in the natural
scene, he can simulate the effect which it would have on
the eye of the observer, by making the relative values of
the shadows more nearly equal, while he adds to the illusion
by making the parts of the picture which are illuminated
by the comparatively feeble light, brighter than they are in
nature.

The cases just mentioned, those in which a very high or a
very low degree of illumination is depicted, represent the
subjects of the greatest difficulty for the painter. The task
of representation is not so great, however, when only a
mean degree of illumination is to be expressed. In repre-
senting such subjects the painter has a greater chance of
success if he but preserve the ratio between his tones, to
which we have referred. There need not be, here, so great
a degree of exaggeration for effect, as in the case of the
representation of great light or depths of gloom, but there
is a delicate gradation of tone from light to dark that must
be most carefully kept. These gradations are sometimes
almost insensible, as for instance in painting flesh. Slight

as it is, there *is* a gradation in light and color, which must be recognized in order to give the effect of light as well as form, yet sometimes it is so small as to be scarcely perceptible. This effect has been exaggerated by a modern French painter, who represents his figures in tints almost flat. The transition from light to shadow is gradual or abrupt, according to the illumination of the object or the texture of its surface. In the diffused light of a cloudy day or that of the interior of a room, there is a gradual succession of tones leading from light to dark, while in the light of the sun on a cloudless day, or when the illumination is produced by artificial light, there is a much more abrupt transition.

The novice is likely to lose sight of the ratio of the intermediate tints and to be prodigal of his lights and shadows. This lavish use of light and shade does not produce brilliancy, but, on the contrary, gives a harsh and unnatural appearance. The happy mean between the two extremes must be sought, and the proper gradation of tones preserved. The tone of the highest light must first be determined, and every other part of the picture must be painted with reference to it. All the delicate gradations from this, the key note of the whole, must be observed with the greatest care.

In spite of the limited scale with which we have to work, the highest light, unless it is the representation of a white object in a strong light, is never white, and, on the contrary, the darkest shadow is never black. The pure white pigment must be reserved for the brilliant effects of strong light, and however dark the shadow may be, it is far removed from blackness. The art of the painter consists in the ability so to manage his lights and shadows that the subject may be modeled by insensible gradations of tone from opaque high lights to luminous transparent shadows.

But to return to the particular branch of the subject which we started out with the intention of considering: the aid which color may give in the representation of light in painting. Certain colors, such as the reds and yellows with all tints related to them, are capable of producing an effect of warmth and luminosity. Yellow is especially useful for such a purpose, and it may be remarked that all natural tones seen under a high degree of illumination, incline to yellow. All colors in strong light exhibit this tendency to take on a yellowish hue, while in shadow they tend more towards blue. The yellow light coming through a stained glass window of this color, will give the impression of sunlight outside on a cloudy day, even a streak of paint, or of

any light colored powder upon the pavement, will appear, at first sight, to be a ray of sunlight. This color is not only associated in our minds with the idea of light, but, as has been said, everything in strong light actually does produce the impression upon our eyes of tending toward a yellow hue. If, then, an effect of bright light is to be produced, this color is a valuable auxiliary. The highest tone of a white object in strong light may even be rendered more brilliant by giving it a very slight yellowish tint, while the increased yellow hue of all colors in the light must also be recognized. On the contrary, the lowering of the tone by making the color of the shadows bluer in tint, will do much toward giving the retiring effect desired. In strong sunlight the shadows cast on any surface of light color, such as a dusty highway, or a field of snow, have a very decided tendency to blue. This effect in shadows must, however, be treated with the greatest care in order to avoid exaggeration.

A high degree of luminosity is attended by a corresponding loss in hue, and colors seen in a very strong light appear paler than in the shade. The artist must also take advantage of this fact, and in his attempt to produce the effect of brilliant illumination he must sacrifice something of his color to gain in the end a greater degree of lumin-

osity. We must make use of our poor substitute for white light and combine our colors with the white pigment, which is to make them paler in tint, but, at the same time, to make them express the effect of light we need in our picture. In this way must the art of the painter conceal the poverty of his resources. The comparison of the utmost that paint can do in the representation of light and color, with the purity and brilliancy of nature's tones, may be discouraging, but the artist's aim must not be the servile imitation of nature. That is rendered impossible by the limitations under which he works. His is a higher object: that of giving a transcription of nature which shall represent some of her moods to others, as they appear to his eyes, and which, while presenting as much of truth as he can see or compass in the rendering, shall yet bear the impress of his own mind and character.

CHAPTER VI.

HE skill of the chemist has placed at the command of the artist of to-day, a palette, comprising pigments of such variety as to leave little to be desired. From the number offered, however, the artist should choose with discretion, for many of these colors, and, moreover, some of the most brilliant and beautiful, are destitute of that most important quality, permanence. That the value of a pigment depends upon the degree of its permanence, is most obvious, yet many of those included in the lists of the colormen, and thoughtlessly purchased and used by artists, are totally lacking in this most important respect.

The careless practice of using colors which are not permanent, has no defensible ground, as it is possible to use

(57)

for the representation of any subject which the artist may desire to paint, such colors only as are reasonably safe from change under the test of time, or any of the conditions to which the painting may be subjected. This being the case, there is no excuse for the artist who uses inferior colors, unless it be urged that it is a matter of economy. It is true that the finest colors, considered as pigments, and apart from the question of manufacture, are generally the most expensive, yet the question of economy is hardly admissible in the consideration of a work of art, and the quantity of the colors used is, ordinarily, so small as to make the matter of cost of very little moment, even were it worthy of being weighed in the balance against durability.

In extenuation of the practice of many artists it may be said, and probably in most cases with truth, that they err through ignorance of the properties of the colors. Time, however, is no respecter of ignorance, and the pictures of the artist who does not inform himself as to the nature of the materials he uses, will fade and change just as certainly as those of him who avows his intention to use what colors he chooses, knowing that they are fugitive, careless of the future, as he paints only for the present. It is clearly the duty of the one to seek the knowledge which

e lacks, while the other may have cause to regret his ourse when he is confronted by the wreck of one of his pictures, an event which may easily happen in his own lifetime.

No artist can afford to risk his reputation on such flimsy grounds as are afforded by the excuses for the employment of many of the colors in common use. Sir Joshua Reynolds made this mistake knowingly, and now, after the lapse of a hundred years, his fame as a colorist rests upon little more than tradition. It does not always, however, require a century to show the results of the use of fleeting colors. A few years, or even months, is generally all that is necessary to complete the ruin of the picture. A correspondent of the London News, writing, not long ago, of the pictures in the new rooms of the Louvre, from his observation of the deteriorating processes going on in the modern pictures there, made the prediction that in less than fifty years half the pictures of the nineteenth century will have disappeared. The correspondent referred the cause to the poor service chemical science has rendered to modern painting. It seems hardly fair, however, to lay the blame on chemical science. If the chemists in their search for something new have discovered some very bad pigments, the

artist is not obliged to use them without regard to their qualities. If he does so, it is at his own risk.

When the picture is sold, the matter becomes a question of honesty. The artist who sells a picture, knowing that it is painted with colors which will fade or otherwise change, is guilty of the same kind of dishonesty as that of the merchant who misrepresents the quality of his goods. If it be granted that it is both foolish and dishonest to neglect the proper consideration of this, to the painter, most important subject, the materials of his craft, it is certainly the part of wisdom for him to learn something of the nature of these materials. The subject is one not unattended with difficulties. Colors which are entirely and undoubtedly permanent, are after all comparatively rare. The discovery of a new one is hailed with delight by chemists, we can not, alas, say by the artistic fraternity, as artists are too generally indifferent to the question of permanence, caring only for brilliant effects in the present and regardless of any changes time may bring.

In the matter of durability, also, pigments range all the way from the undoubtedly permanent under all conditions, in a descending scale of various degrees, to those which are certainly known to be fugitive. Then, too, they

are not only to be considered alone, but in combination with each other. Some colors, perfectly durable in themselves, may be unfavorably affected by the chemical properties of others with which they are combined, while others, fugitive in themselves, may be rendered more permanent by admixture with others which have a preservative effect upon them. In any case, it is hardly possible to pronounce an opinion which may not be disputed by the results of some peculiar circumstances.

A color, also, which has proved fugitive in the work of one artist, may have been found to be durable in that of another. It is the experience of chemists that the same combinations, under apparently similar conditions, do not always produce like results. When we consider the conditions of the combination of colors, varied as it must be by the peculiarities of manufacture, and also by the handling of different artists, it is not surprising that the result cannot always be positively predicted. There is, perhaps, no color so permanent that it will not suffer injury from some abnormal condition, or none so fugitive that it will not, in some one's experience, disprove its reputation.

We cannot, however, consider the colors under such unusual conditions, but choosing those of a reputable man.

ufacturer, we must make use of such as by reason of their chemical properties may be suppossed to be reasonably free from change under such normal conditions as ordinary light, heat, or combination with each other. When an artist can choose between two colors producing similar effects in use, one of which is permanent and the other fugitive, only the grossest ignorance or a virtual dishonesty of intention is shown by the choice of the latter. In some cases the fugitive color possesses such beauty and brilliancy that no permanent color has been found to take its place. This increases the temptation to make use of such colors, but the cases are fortunately not numerous, and it may be affirmed that it is quite possible to select a palette which shall embrace all the colors necessary, and which shall, at the same time, be practically permanent.

CHAPTER V.

Colors—*Continued.*

E will now consider the claims of the various pigments, with the purpose of forming a palette which shall meet all necessary requirements in the way of variety and permanence.

In oil painting, white may be said to be the most important of all the pigments, as it enters into every tint in larger or smaller proportion, and upon it depends the luminous quality of the picture. The choice in oil colors is practically limited to the whites made from lead, and zinc white. The lead whites, cremnitz, silver and flake white, are the pigments most generally used. The first of these is the best. It has great body, and is the most brilliant white known, but in common with all whites made from lead, it has some serious defects. The most annoying is its tendency to turn yellow, if the picture in which it is used is placed where

there is an absence of strong light. It has, also, a tendency
to blacken in an atmosphere containing sulphuretted hydro-
gen. As it is usually exposed to the first of these condi-
tions, and sometimes to the last, in the light and atmos-
phere of an ordinary house, its use is scarcely to be
recommended.

The chemical action of the lead is, moreover, injurious to
some other colors, when it is used in combination with
them. It is said, also, that white lead loses its body, be-
coming, after a considerable lapse of time, partially trans-
parent. This result is probably due to a process of oxida-
tion, caused by the action of the atmosphere upon the sur-
face ; by which it is continually eaten away. The difficulty
concerning the chemical action of lead upon certain other
colors might be avoided by leaving such pigments out of
the palette, or by mixing them with another white, such as
zinc white, when used. It would, however, be annoying,
while painting, to be obliged to consider whether certain
colors were inimical to each other and to avoid mixing
them.

There is still another objection to the use of lead white,
which I am inclined to believe, has greater force than most
persons imagine, and that is its poisonous quality. The

COLORS—*continued*. 65

injurious effects upon the workmen employed in handling it
at the factories where it is manufactured, are well known.
But even in the comparatively small quantities employed in
artistic work, there is risk of injury which may be felt in
proportion to the susceptibility of the persons by whom it
is used. When using pigments of such poisonous nature it
is best to protect the skin in handling them, as the poison
can be absorbed by contact. The hands may be protected
by wearing gloves, but when white lead is used in any
considerable quantity, it gives forth a strong odor, which is
not only disagreeable in itself, but deleterious to health.

In consideration of the numerous drawbacks attending
the use of white lead, we are justified in excluding all pig-
ments made from lead from our palette. We turn, there-
fore, to the only other available white, that made from
zinc, and find in it all the qualifications necessary to replace
the whites of lead.

Zinc white, when properly prepared, is a brilliant white of
sufficient body, and is entirely permanent. It is difficult to
understand why this pigment, practically unalterable as it
is, should not, in use, have replaced to a greater extent
than it has done, the objectionable white lead. For more
than a century its good qualities have been known to

chemists. Among other favorable reports upon this pig-
ment, was one made as long ago as the year 1808, to the
Institute of France, in which its use was recommended as
preferable to that of white lead, and in which it was stated
that to the advantage of the absence of qualities injurious
to health was added the fact that the tints produced with
it were clearer and purer, while, if its brilliancy was not
so great, it did not tarnish. It does not dry as quickly
as white lead, for the reason that it does not, as the lead,
form a chemical compound with the oil with which it is
mixed. This does not cause any inconvenience in working.
On the contrary, it is rather advantageous, and besides les-
sens the risk of cracking. This pigment is not supposed
to be entirely innocuous to health, but in artistic work its
use may be practically so considered. Its comparative free-
dom from injurious qualities, combined with its merit of re-
maining unaffected by the action of light or impure air, ren-
der zinc white, therefore, the best white pigment we have.

We will next consider the reds. Although not compris-
ing all that might be desired, the list of permanent reds is
sufficient for our absolute needs. A brilliant transparent
scarlet would be a very desirable pigment, but, although the
value of such a pigment is fully realized, and it has long

been sought, even with the stimulus of liberal rewards, no permanent red of that description has yet been found. We . are limited, therefore, to opaque scarlets, and among these there are no colors whose claims entitle them to consideration, except the various preparations of vermilion. Pure scarlet, the most brilliant and transparent red known, is so extremely fugitive as to be unworthy of mention. Red lead, although more durable, is still so liable to be affected by impure air and by admixture with other colors as to be undesirable. The choice must, therefore, fall upon one or other of the preparations of vermilion.

Vermilion is a sulphide of mercury and, when pure, a brilliant and permanent color. It does not dry well, and is of such opacity as to be somewhat difficult to manage in mixtures. When not of fine quality it is said to turn brown in time, yet it may be considered as, practically, a permanent pigment which has stood severe tests. As such, and as, moreover, the only available red of so brilliant and durable a color, we are justified in adding it to our palette.

Of the different preparations known under the names of vermilion, Chinese vermilion and orange vermilion, the first is probably the best choice. Chinese vermilion or carmine

vermilion is slightly more brilliant in color, and orange vermilion is, as its name indicates, of an orange tint, and is more transparent than the others. The preparation known as Field's orange vermilion is very brilliant, and being, as has been said, more transparent than other vermilions, is, therefore, better in mixtures. When an orange red is desired, however, there is nothing better than cadmium red.

Cadmium Red is a simple pigment containing no base but cadmium, and is of a brilliant orange scarlet color, partially transparent and absolutely permanent.

Among reds of more sober hue, we have Indian, light, Mars and Venetian reds and red ochre. Indian red, light red and red ochre are natural pigments, and belong to the class of ochres, while Mars red and the Venetian red, now manufactured, are compounds of a similar nature, artificially prepared. All these colors are composed of oxides of iron, but in the artificial ochres, the iron is, chemically, more active in mixtures, with other colors, and so more likely to be injurious to those colors which cannot be safely mixed with iron. We will select as the most useful among these reds the following:

Indian red, a natural earth, rich in peroxide of iron; of
a fine, dull red color, and very permanent.

We now have to consider the transparent rose colored
pigments. These are mostly comprised under the heads of
madder and cochineal lakes. The latter are known as
scarlet lake, crimson lake, purple lakes, Roman lake, &c.,
and are all derived from the cochineal insect. They are rich
and brilliant colors, but are injured by strong light and
by admixture with certain other pigments, particularly lead
whites and vermilion. The madder lakes are obtained from
the root of the Rubia tinctorum, and are known as madder
carmine, rose madder, pink madder and madder lake. They
are the only permanent lakes, and are, moreover, very beau-
tiful colors. They are permanent under all conditions,
except that they are somewhat liable to injury when mixed
with lead or iron pigments.

We will add *rose madder* to our palette, remembering,
however, that it is subject to the conditions as to admixture,
mentioned above. As to the danger of admixture with
white lead, we have avoided that by selecting zinc white
instead of one of the lead whites, and as to the other condi-
tion of admixture with iron colors, we will render the liabil-
ity as small as possible by leaving out the artificial ochres,

which, as has already been mentioned, are, chemically, more active than the natural pigments. The natural ochres or iron colors will, therefore, be less dangerous when mixed with rose madder, but we will be certain of security from changes if we avoid mixing any of the ochres with it.

There are a few orange-colored pigments which merit attention. The principal ones are cadmium orange, burnt Sienna, chrome orange, Mars orange and burnt Roman ochre. The first of these is a fine, permanent color, but it will not be necessary to add it to our palette, as we have already cadmium red, and will add deep cadmium among the yellows as more useful than the one under consideration.

Burnt Sienna is prepared by calcining raw Sienna, and is, therefore, of the same nature, i. e., a natural pigment containing iron. It is a fine transparent brown, inclining to orange, permanent, except with possibly a slight tendency to deepen in time. We will add it to our palette as the only one in this class which we will find necessary.

Chrome orange is made from a base of lead, and is, therefore, likely to discolor in an impure atmosphere, and, also, likely to injure other colors by admixture. It is said to be somewhat better than the chrome yellows, but, considering the defects mentioned, quite out of the question in

a palette of permanent colors. Mars orange is open to the objections made before as to the artificial ochres, also bearing the name Mars, of being less safe than the natural ochres in mixtures with colors that can be injured by iron. Burnt Roman ochre is permanent, but unnecessary.

We will now consider the merits of that important class of pigments, the yellows. In this we will find a larger assortment of permanent colors than in any other. Of practically permanent pigments we may choose from the following list: Aureolin, cadmium, lemon yellow, Orient yellow, raw Sienna, the ochres, Naples and Mars yellow.

There are a number of yellow pigments which are not durable, the best known of which may be briefly mentioned: Chrome yellow is, like the orange chrome, already noted, a chromate of lead and subject to all the defects of lead colors. In color it is so crude and disagreeable that one would hardly consider it necessary to warn artists against it, had it not in some unaccountable way come into general use. Its true characteristics have so frequently been exposed of late, that it is to be hoped it has lost some of its popularity. Likewise lacking in permanence, is citron yellow, which changes on exposure to light and air; Kings' yellow or orpiment, which, besides being unsafe in mixtures with other

colors, is extremely poisonous; yellow lake; Italian pink, (which is the curious name of a very brilliant, transparent yellow), and Indian yellow. All these colors are fugitive, and, therefore, to be avoided.

Of the permanent pigments mentioned above, we will choose for our palette, aureolin, cadmium, Orient yellow, raw Sienna, and one or two of the ochres, leaving out Naples yellow, which, although said to be permanent as now manufactured, is unnecessary, and, also, Mars yellow, because it is an artificial ochre, while we have a number of natural ochres from which to choose.

Aureolin, a compound of cobalt, pottassium and oxide of nitrogen, is a beautiful semi-transparent yellow, which is said to be the most permanent yellow known. It is useful in mixtures on account of its partial transparency, but is of no great power. Winsor and Newton's preparation is somewhat pasty, and the pigment seems to separate from the oil and become too dry. As it is a useful and beautiful color when properly prepared, and this experience may have been exceptional, we will add it to our palette.

Deep cadmium is a sulphide of cadmium, a brilliant yellow, inclining to orange, a splendid color, and one which is entirely permanent. The deep cadmium is chosen from several

cadmium yellows, as it is the richest color, and, because, in the case of these pigments, the deeper the colors the greater is the degree of permanence they possess. The pale cadmiums are not considered as permanent as the deeper colored varieties, and a pigment called lemon cadmium or Mutrie yellow is said to be decidedly fugitive.

Orient yellow is a comparatively new pigment of a brilliant yellow hue, which is said to be absolutely permanent. It is so fine a color and one which will be found so useful that we cannot omit it from our palette.

Raw Sienna is of a dull yellow color, very transparent and permanent. It is a natural pigment, containing iron, similar to the ochres, which we will now consider.

There are several ochres, any one of which would make a valuable addition to the palette. Those best known are yellow ochre, Roman ochre, Oxford ochre and transparent gold ochre. Yellow and Oxford ochres are of a moderately light, dull yellow color, and rather opaque. Roman and transparent gold ochres are darker and more transparent.

Yellow ochre is the most commonly used of the ochres, and a very valuable pigment. Like all the ochres it is permanent, except that it has, possibly, a tendency to turn darker in time. Transparent gold ochre has the advantage

of being stronger in tone and more transparent, and might, perhaps, be the most generally useful, but it would be well to add both yellow and transparent gold ochres to our palette, although both are hardly necessary. As yellow ochre is a standard pigment, which is so exceedingly useful, and is also one which can invariably be procured, it will be best, perhaps, to select it as the one most desirable.

We will now endeavor to find a green which can be added to our palette. Numerous greens can be formed from the mixture of yellows and blues, and most of the greens used must be so compounded, yet there is one green so beautiful and so durable that we cannot afford to do without it. This is viridian.

Viridian is a comparatively new preparation, formed from oxide of chromium with a little water. It is also known under the names of Paul Veronese and permanent green. It is a rich, deep green, transparent, brilliant, and very permanent, and will be found very useful in mixing tints. Aside from viridian, there are in the list of greens scarcely any which it will be worth our while to consider. The other oxides of chromium of various tones are stable, but not equal in beauty to the one we have chosen.

The various copper greens, such as malachite, emerald,

vertigris, and others made from copper alone, and in combination with arsenic, have a tendency to darken in time. They are also very poisonous, and in the case of emerald green the color itself is objectionable, as it is so crude and rank as to be injurious to the artistic effect.

There are also various compounds of Prussian blue with yellow, which cannot be considered permanent, inasmuch as the blue pigment is fugitive, and the combination, even if the yellow is permanent, cannot be stronger than the weakest element in the mixture. The pigments commonly called chrome greens are compounds of chromate of lead and Prussian blue. The greens known as Brunswick green, English green and green cinnabar are also similar compounds, which may vary in degree of permanence according to the method of manufacture, yet none of these pigments can be considered as permanent on account of the elements which enter into their combinations. Hooker's green and Prussian green are compounds of Prussian blue and gamboge, which are liable to the same objection of want of durability. Sap green or *vert de vessie* is a vegetable pigment which is not durable. Terre verte is a dull, greyish green which, although it may be considered permanent, is unnecessary.

When we enter upon the search for the blue pigments, which are most useful, both alone and for the composition of greens, we find the number very limited. Indeed, when the question of durability is considered we find that there are but one or two which are worthy of being added to our palette. The one perfectly unexceptionable pigment among the blues is genuine ultramarine.

Genuine Ultramarine is made from Lapis Lazuli, and is, necessarily, an extremely expensive pigment, as well as a perfectly durable one. Its great cost places it outside of general use. A method of manufacturing an artificial ultramarine which possesses, in a considerable degree, the qualities of the genuine, was discovered by M. Guimet in 1828, and shortly afterward by M. Gmelin. These ultramarines are similar in their chemical constitution to the natural pigment, being compounds of silica, alumina, sulphur and soda, and are known under various names, such as factitious or artificial ultramarine, *outremer de Guimet*, Gmelin's blue, *bleu de garance*, brilliant ultramarine, new blue and permanent blue. Artificial ultramarines, when well made, are permanent. Those having the most color are considered the best.

Brilliant Artificial Ultramarine is said to approach nearest

the genuine ultramarine in color, transparency and chem-
l constitution. We, therefore, select it from among the
tificial ultramarines for our palette. This is a splendid
lor, brilliant, deep and transparent, and will suffice as our
ly choice among blues.

There are two other blues which are good and dura-
:, although not, perhaps, in so high a degree as the ul-
marine, viz: cobalt and cerulian blue. The first of these
slightly effected by light and impure air, and the latter
said to assume a greenish tint in time. These are the
ly blues which have any claim to permanence.

There are several other blue pigments which, as they are
ll known and commonly used, it may be well to mention
order to warn artists against them. These are smalt,
ligo, intense blue, Antwerp or mineral blue and Prussian
ue. These are all more or less fugitive. The last men-
ned, however, is so magnificent a color that it is hard to
cide upon its banishment from the palette. There is no
lor that will fill its place. Its intense and brilliant hue, as
ll as its great transparency, render it most desirable, but
en if under favorable circumstances, it may last well; it
so sensitive to less favorable conditions, fading under the
tion of strong light, and darkening and changing color in

impure air, that it is not a safe color to use. A permanent pigment possessing the power and transparency of Prussian blue would be a very valuable addition to the palette. Antwerp blue, a color which seems to be in common use, is still less permanent than Prussian blue. In default of other blues, however, a good ultramarine will answer all purposes, and will be sufficient for our palette.

If a purple is desired, the best choice would be *Purple Madder*, which has the qualities of the other madders, as well as the same degree of permanence.

Purple lake, burnt carmine and burnt lake resemble the lakes, and are not, therefore, as durable as the madders. Violet carmine is not permanent; Mars violet, an oxide of iron, is a permanent pigment, yet neither necessary nor desirable as an addition to our palette. Indeed so seldom would a purple be needed, or, if needed, so easily can it be made from rose madder and blue, that it is really unnecessary to choose any pigment from this class.

There are numerous brown pigments, nearly all of which are permanent. Among permanent browns may be mentioned, brown madder, Rubens madder, Prussian brown, burnt umber, Verona brown, Vandyke brown and Caledonian brown. The browns which should be avoided on

account of lack of permanency are Cassel and Cologne earths, mummy brown and bone and ivory browns.

One most tempting pigment in this class, which is in common use, requires a particular notice as a warning to artists. This is asphaltum, which, as a pigment, should be labeled "dangerous." When in the form of a solution in turpentine, it is called asphaltum, and when mixed with drying oil, it goes by the name of bitumen or Antwerp brown. It is of a fine brown color, and possesses such perfect transparency as to render it very valuable in mixing tints, but it has a tendency to blacken, and, moreover, a liability to change and crack from the action of the atmosphere and from variations in temperature. Its qualities are such as to render it most unsafe, and in spite of its seductive tone and manner of working it is a very undesirable preparation.

From the list of permanent browns we will choose for our palette *Brown Madder,* a rich and transparent brownish crimson or marrone, and *Caledonian Brown,* a transparent russet brown. These will, in all probability, be sufficient.

Of browns with a citrine or olive cast, we have as permanent pigments raw umber and Mars brown. Either of these may be considered durable; the former is a natural

ochre, with a possible tendency to darken in time, but having no injurious influence on any other pigment, the latter is either a natural or artificial ochre of strict permanence. We will select *Raw Umber* on account of its slightly more citrine cast.

Gray, which can easily be made by a mixture of black and white, the tint being varied as desired by the addition of other colors, is unnecessary as a separate pigment. Gray has been distinguished from grey by defining it as a neutral tint, which is colored by the addition of some other pigment besides black and white. Grey is described as a tint formed by the union of black and white only. There are several gray pigments in general use. Of these may be mentioned mineral gray, ultramarine ash, neutral tint and Payne's gray. Ultramarine ash, as its name indicates, is obtained from Lapis Lazuli, after the blue has been extracted, and mineral gray is a product of the residuum after both the blue and the ash have been procured. Coming from such a source, these pigments may be considered permanent. The other two pigments mentioned are also generally considered permanent, but the first, neutral tint, is liable to become colder in tone, and Payne's gray, although useful in mixing tints, is a very

unsatisfactory preparation. In my own experience I have found it a most dangerous pigment, as when used in combination with yellow or transparent gold ochre and white, it, in a very short time, disappeared almost entirely. These preparations are, however, as has been said before, quite unnecessary, as gray can be so easily compounded.

Lastly, we will consider the black pigments, which, considering the frequent use made of them, are quite important. In this class may be mentioned, ivory black, bone black, lamp black, cork black and blue black. Ivory black is made from charred ivory, and is, therefore, a sort of animal charcoal. This charcoal has the singular property of absorbing the color of any animal or vegetable solution. It can be imagined that its influence upon other organic pigments would be deleterious, although this quality would be shown more particularly in water color, for in the case of oil colors the oils and varnishes used act in some degree as a preventive. Bone black and lamp black are similar in their nature, and are somewhat undesirable in mixtures, as they are very dense and heavy. Cork black, which is obtained from charring cork, is a black of no great intensity. The last named in the list above, blue black, otherwise called charcoal, Leige or vine black, a charcoal

prepared from vine twigs, is probably the best pigment
to select for our palette.

Blue Black is a black of a bluish cast, not so dense as
lamp black or ivory black, and, therefore, more desirable
for mixtures. Its slight bluish cast also renders it very
valuable in the composition of grays.

To recapitulate, we have, therefore, selected for our
palette the following pigments:

White—Zinc White.

Red—Vermilion, Cadmium Red, Indian Red, Rose Mad-
der.

Orange—Burnt Sienna.

Yellow—Aureolin, Deep Cadmium, Orient Yellow, Raw
Sienna, Yellow Ochre.

Green—Viridian.

Blue—Genuine Ultramarine or Brilliant Artificial Ultra-
marine.

Purple—Purple Madder.

Brown—Brown Madder, Caledonian Brown.

Citrine—Raw Umber.

Black—Blue Black.

To these eighteen pigments several other excellent colors,
such as Transparent Gold ochre, Burnt Roman ochre, Mars

Brown, &c., might be added, but they are by no means necessary, and the list as given above will be found ample for all practical purposes. Indeed, in practice few artists would use so many colors. Some may consider this palette too limited, yet, having gone through the list of pigments from which we are obliged to choose, we can realize the difficulty of securing colors which are perfectly unexceptionable in the matter of durability. It is to be hoped that the importance of this question has been made evident, also the fact that it is one which no artist can afford to ignore. We have, therefore, to choose for our palette such pigments as from their chemical constitution may be expected to resist the action of time under the ordinary conditions to which they shall be exposed, and which will not be inimical to each other in mixtures. These conditions have, we think, been fulfilled in the list given above, and it is offered as a palette of colors, which, if properly manufactured, can be used with perfect safety, and at the same time will afford all necessary variety.

CHAPTER VI.

MATERIALS.

F all the materials of the paint-
er's craft, the most important
are, necessarily, the pigments.
We have been considering the
chemical composition of the colors, and
it now remains, only, to select those
which may reasonably be supposed to be
free from adulteration. A great many
complaints have been heard of late in regard to
the durability of pigments. The unfortunate
effects observed in many paintings of compara-
tively recent date, which have given rise to
these complaints, may in many cases, as we have before
suggested, be due to the carelessness of the artists them-
selves. When artists do not take the pains to inform them-
selves as to the chemical character of the substances they

(84)

se, they have no right to blame the manufacturers when he natural results of improper combinations or the use of lements in themselves fugitive ensue. While it may be rue that there are pigments placed upon the market, poor n the quality of the chemicals of which they are composed, r imperfect from careless methods of manufacture, the esults complained of can, in all probability, be more frequently charged to the vehicles with which they are mixed, r which are used with them in painting, than to the pigments themselves.

In this age of adulterations the artist is, perhaps, peculiarly liable to suffer from this cause, and as he cannot take ime, as did the old artists, to manufacture his colors himself, he must trust to the honesty of the colormen. The only refuge he has, therefore, is in the selection of pigments made by manufacturers of such reputation as shall be a guarantee that their productions are as represented.

I have submitted specimens of the pigments comprised n the list which has been given in the previous chapter, and manufactured respectively by Dr. Schoenfeld, Hardy-Alan and Winsor and Newton, to severe tests of exposure to the sun, air, and interior atmosphere for a long time, with very satisfactory results. From the issue of these experi-

ments and use in ordinary practice, I can recommend the palette given as practically permanent, and the pigments as manufactured by the above mentioned dealers, as capable of standing all necessary tests.

Of the three mentioned, my own preference is for the German colors, manufactured by Dr. Schoenfeld. These pigments, in perfection of manufacture, grinding and combination with their vehicles, purity of hue and permanence, leave little to be desired. There is, also, a detail which in use renders these colors more convenient than the English, which, while of no special importance, is yet the cause of a considerable saving of time and trouble. This is the use of a label on the tubes, colored to represent the tint of the pigments contained within. This practice, also, obtains with the French manufacturers, and is gratefully noticed by the painter when hurriedly searching for the color wanted from a full color box.

The French colors of Hardy-Alan are also excellent, as are the well-known pigments of the English firm of Winsor and Newton. It is best that the pigments should be of one manufacture, although it may sometimes be desirable to use a certain pigment not to be found among the productions of the manufacturer you have chosen. I have not experi-

mented with the American colors, and so am unable to speak from personal knowledge as to their durability, or the excellence of their manufacture. I have found, however, Devoes' zinc white an excellent preparation. It has a dryness of consistency which is very much valued by artists, especially in a white pigment.

It is my purpose, in this chapter, to give a complete list of the materials necessary in oil painting, with the prices, so that the cost of an outfit may be easily computed. We will begin with the colors, giving the list of those already decided upon for the composition of our palette with the corresponding prices of English, American and German manufacture. Of the French, Hardy-Alan, colors, mentioned above, I have been unable to obtain a complete list of prices, but can say that, as quoted in the lists of dealers, they represent, in most cases, double tubes, so that, although the prices may appear higher, they are really lower than the others when the quantity furnished is considered. Genuine ultramarine is the most expensive color and is prepared by Messrs. Winsor and Newton for $3.25 per tube. Fortunately artificial ultramarine can be substituted for it. In the following list the prices of the several manufacturers can be compared:

COLORS.	WINSOR AND NEWTON.	AMERICAN.	COLORS.	DR. SCHOENFELD.
	pr. tube	pr. tube		pr.tube
White				
Zinc White............	10	8	Zincweiss	10
Reds				
Vermilion...............	18	15	Zinnobar................	15
Cadmium Red..........	45	30	Cadmiumroth............	35
Rose Madder..........	28	25	Krapplack No. 2, Rosa...	28
Indian Red............	10	8	Indischroth..............	10
Orange				
Burnt Sienna..........	10	8	Gebr. Sienna	10
Yellows				
Aureolin	80	60	Aureolin.	35
Deep Cadmium........	45	30	Cadmium No. 4, dunkel	35
Orient Yellow..........	80
Raw Sienna...........	10	8	Terra di Sienna	10
Yellow Ochre..........	10	8	Lichter ockre............	10
Green				
Viridian..............	28	25	Permanent Grün dunkel..	10
Blue				
Brilliant Ultramarine...	45	25	Dunkler Ultramarin	15
Purple				
Purple Madder	45	35	Krapplack No. 8, dunkelster purpur	50
Browns				
Brown Madder	18	15	Madderbraun	25
Caledonian Brown......	10	8	" "	10
Citrine				
Raw Umber...........	10	8	Umbra	10
Black				
Blue Black............	10	8	Rebenschwarz............	10

We can now compute the relative cost of the pigments of the different manufactures. I have been unable to find a permanent yellow corresponding to the English orient yellow in the lists of the other manufacturers; neither have I been able to learn its chemical composition. It is rec-

ommended, however, as a perfectly permanent color, and is a very brilliant and useful pigment which seems to bear the test of time and exposure. If we add to the other lists the English orient yellow, we will have on comparison of complete lists of the colors comprising the palette, prices as follows:

English, $5.12.

American, $4.04.

German, $4.08.

The question of cost is one, however, which should not enter into this matter. It is not, usually, of moment, as the quantities are so small, and this is, certainly, the last place where economy should be practiced. The list as given includes nearly all the *permanent* pigments which can be procured. Some good colors have been omitted because they resembled very nearly, others chosen as the most desirable, and were, therefore, considered unnecessary.

When the questions of hue, permanency and chemical action upon each other in mixtures, are considered, it will be found that this list practically comprises as varied a palette as is placed at the command of the artist of the present day. Additions are constantly being made to the lists of pigments, and there are many preparations known

to chemists as desirable, which, for some reason or other, have not yet been placed upon the market. While the list as given above can hardly be considered extravagant in regard to variety, and while it is intended for general use, and includes nothing which may not at some time be necessary, it is possible that for a palette designed for ordinary use some of the pigments might be omitted. A list of palettes for different kinds of work will be given, which may serve as a guide to any one desiring to select pigments for any special purpose.

The question of the number of pigments used, is one, however, which must be settled according to the idiosyncracies of the artist. Some artists make use of a large number of colors, while others prefer working with a very limited palette. In mixing several pigments together, the chemical combinations are necessarily complicated, and the risk of change from this source increased. Mixture, also, tends to deaden the brilliancy of the hues, yet I do not think it good practice for a painter to embarrass himself with too many colors. It is better for a beginner to learn the possibilities of a rather limited palette with whose combinations he can become familiar, than to involve himself in the complications of a more extensive one. It is possible by judicious com-

binations of a few colors which are innocuous to each
other, to obtain all necessary variety of tint, while at the
same time the risk of getting the tones out of harmony
with each other is lessened.

Taking the list of colors as given, and choosing those of
Dr. Schoenfeld's manufacture, we can make out a list of
the articles required for a complete outfit as follows:

Eighteen tubes of colors, including the English orient yellow, at 80 cts..$4	08
Enameled tin box for colors	1 25
Palette	30
Palette knife, of flexible steel, for use in painting, of French manufacture, either Hardy-Alan or Colin	1 00
Mahl stick, (white wood)	15
Turpentine	15
Linseed oil	15
Bottle Soehnée Fréres' retouching varnish	25
Easel	90
Brushes	1 00
Tin cup	10
Total	$9 33

The cost of these articles, as given above, represents the
lowest estimate. In regard to several items, such as the
easel, palette, mahl stick and box, the cost can very easily
be increased, as the luxurious tastes of the artist demand,

or his purse may permit. There are some additions to the cost of this outfit, however, which can hardly be avoided. The tubes of color must, of course, be constantly replaced as they are used, but there are some pigments of such general use that it would be well to order more than a single tube in the beginning. White is so much used that it is better to get it in double or quadruple tubes. Of yellow ochre there should be two or three tubes, and also more than one of burnt Sienna. The estimate for the brushes also, allows only five or six. This number should be increased according to the needs of the artist, which will vary very much according to his individual manner of working.

The matter of brushes is a very important one. The best are those called the "Munich brushes," manufactured by Weber, of Munich. They are made of hair, which, while firm and elastic, is very pliable, and are, in use, far preferable to the stiff hog's bristle brushes. The prices range from twelve cents for the smaller sizes to twenty-five for the larger. The brushes chosen should be flat and as broad as the artist can conveniently use. The size will, of course, depend upon the scale of the painting, but the beginner should avoid the habit of working with small brushes.

٠ If out-door work is contemplated, there may be added to the outfit of the artist the very convenient folding easel, costing $2.00, and a camp stool at sixty-five cents. There is, also, a large umbrella to shield the sketcher, which can be procured for $10.00.

Without allowing for any luxury in the material of the articles, with a dozen and a half of the best colors, and six or eight good brushes, we may say that an outfit for oil painting can be procured for about $10.00.

CHAPTER VII.

ON CERTAIN CHANGES CAUSED BY THE MIXTURE OF PIGMENTS.

HE mixing of pigments is sometimes attended by changes which would not be expected from the known characteristics of the colors combined. These results are especially to be noted when white is mixed with certain other pigments. White enters into the combination of nearly every tint in oil painting, and it is necessary to understand something of the peculiarities of its manner of combining with other colors. It does not always act, simply, to lighten the tint, but frequently produces an actual change of hue. This is especially noticeable in the combination of black with white, from which we obtain a gray with a decided bluish tint. A very thin layer of white paint over a dark ground, will also present a similar appear-

ance, and the result comes, in both cases, from the peculiar effect of light transmitted through a semi-translucent medium. This effect is intensified when the semi-translucent medium is over a dark background.

The production of a bluish tint in this way, is often seen in nature. The blue of the sky is said to be only the effect of light transmitted through the medium of the atmosphere lying between us and the darkness of space beyond. We find here the explanation of the intensely blue color of the sky as seen from high elevations where the atmosphere is clearer, and, also, of the ordinary phenomenon of- the deep blue of the upper sky as compared to the pale, hazy effect at the horizon. The gorgeous yellow and orange tints of the sunset are due to the fact of the light being then transmitted through a thick intervening medium of atmospheric vapor. Similar effects may be noticed in some kinds of opalescent glass, which appear quite blue by reflected light, or in light coming through the more translucent portions, while that transmitted through the more opaque parts gives beautiful tints of red and orange. To the same peculiarity of light coming through a partially translucent medium, is due the bluish tints of distant mountains which diversify the land-

scape so beautifully, and vary with every passing state of the atmosphere.

The artist may derive lessons from the study of the causes of these natural phenomena, which will help him in his attempts to represent them : For instance, in painting a sky, he should endeavor in his small degree to portray it, not as a blue canopy stretched above him, but as a partially transparent medium through which light passes. He must not sacrifice the light to the color, but must remember that it is light, accidentally appearing blue, but yet light intensely brilliant as compared to terrestrial objects. Deep as sometimes seems to be the color, it will be found far removed from a pure blue. If represented as really blue, it will be out of harmony with the landscape, as well as deficient in luminosity.

There is after all no color in the use of which it is necessary to exercise so great care as blue. Anything approaching a pure or saturated blue will always be found out of harmony in art. In many cases the blue which we have found to be the accidental result of the mixing of black and white will be found sufficient. In painting flesh artists generally use blue in the shadows, but by the use of blue black, which has a slightly bluish cast, tints may be formed quite blue

enough for any possible tones of flesh. Even in painting
blue eyes, a blue pigment is unnecessary. The combination
of blue black and white, perhaps, even then warmed with a
little yellow, will furnish the proper hue. This use of black
and white will also be an imitation of nature's method in the
case, for it is said that·the color of blue eyes does not result
from the presence of blue coloring matter, but simply from
the optical illusion, to which we have referred, due here to
the effect produced by a semi-transparent membrane spread
over a dark background. This effect observed in the mixing
of white with black is also seen in the combination of white
with other pigments in a lesser degree. With various reds,
especially with those at all inclined to violet, it forms tints
with a decided tendency to purplish hues. With Indian
red the combination assumes so purple a hue that, although
it is frequently used in painting flesh, I cannot think it de-
sirable for the purpose. In mixtures of opaque yellows
with black, similar results are seen, and tints with a decided
greenish tendency are formed, the yellow not being simply
darkened, as might be supposed, but assuming a hue as
green as if blue had been introduced into the mixture.
From these peculiarities in the mixing of pigments, it is
quite possible to obtain tints as blue or green as will ever

be needed in painting flesh without running the risk of forming tones too decidedly of this nature. By studying the peculiar qualities of pigments in combination the artist can limit his palette, and at the same time lessen the risk of producing inharmonious tints.

CHAPTER VIII.

PALETTES.

THE palettes given here are offered simply to guide the student in the selection of colors for certain classes of subjects. When one considers the infinite combinations which can be made with a few pigments, it can easily be seen how impossible it is to give scheme of color for painting any special subject, which shall be more than a suggestion. As mere suggestions, therefore, as to what colors might be used to produce certain combinations of hues, these palettes are given:

FLESH TINTS.

Zinc white,
Aureolin,
Burnt Sienna,
Vermilion,

Yellow ochre,
Brown madder,
Cadmium red,
Blue black.

Rose madder,
Deep cadmium,
Raw umber,

A most useful and simple palette for flesh tints, will be found in the following colors:

| Zinc white, | Yellow ochre, | Burnt Sienna, |
| Vermilion, | Rose madder, | Blue black. |

To which brown madder may be added for warm shadow tints in the lips, &c. Vermilion is a peculiarly heavy and opaque pigment, and is, in consequence, somewhat difficult to manage, yet it is the best available red for the purpose. Some artists like to use cadmium yellow in the shadows of flesh, and a bright yellow of that kind might be used, if desired, instead of yellow ochre. Aureolin, from its more transparent quality, would furnish fine flesh tints, and with rose madder and white would give very delicate and durable hues. Cadmium red is also useful for this purpose. Each artist must discover for himself the scheme of color which he can handle best, but he will, I think, among the colors mentioned above, find all that will be necessary. If desired, raw umber could be used in making shadow tints instead of black.

LANDSCAPE.

Zinc white,	Ultramarine,	Orient yellow,	Viridian,
Raw Sienna,	Raw umber,	Burnt Sienna,	Blue black,
	Deep cadmium,	Yellow ochre.	

Aureolin may be used in greens made from white, ultramarine and yellow; or white, viridian and yellow; instead of orient yellow or cadmium. It may not be necessary to have all the yellows mentioned, but they are all excellent colors and will be found useful. A dark green for foliage may be made with viridian and burnt Sienna, which may be lightened with yellow ochre. A very brilliant green may be composed of viridian, orient yellow and white, and one inclining more to russet tones may be made from viridian, cadmium yellow and white. Good greens may also be made with viridian and raw Sienna. Blue greens may be composed of viridian and white, or viridian white and ultramarine. Gray greens may be made by the addition of black to any of the greens already given, or with viridian, burnt Sienna and white.

MARINE PALETTE.

Zinc white,	Ultramarine,	Yellow ochre,
Viridian,	Aureolin,	Brown madder,
Burnt Sienna,	Blue black.	

The tints of water are, of course, infinitely varied according to the state of the atmosphere, the light, &c.; yet the palette given above will probably furnish as great a variety

as would be necessary, unless boats and figures requiring
special hues are introduced, or that representations of sunset
effects should be attempted when it would be necessary to
add some of the reds. The deep blue of distant water seen
on a clear day may be represented with ultramarine, virid-
ian and burnt Sienna with a little white. For the middle
distance the same colors can be used, allowing the green to
predominate. The red tint of the sea which sometimes
comes from the presence of sea weed can be given by the
use of brown madder. For the waves of the sea near
the shore the greens are quite pronounced and sometimes
very brilliant. Aureolin might come in play here. Brown
madder will also be necessary in some shadows. and re-
flections. The sand of the shore may be painted with
white, yellow ochre, burnt Sienna and a little blue black.
The shadows with the same in the blue gray tint, made
by the blue black and white with less of the Sienna as
the shadows in the sand are very blue. The tints are,
however, so varied by every change of time and atmos-
pheric conditions that it is impossible to give more than
a suggestion for certain more commonly observed effects.

FRUIT AND FLOWERS.

Zinc white,	Blue black,	Vermilion,
Aureolin,	Cadmium red,	Deep cadmium,
Rose madder,	Orient yellow,	Indian red,
Raw Sienna,	Burnt Sienna,	Yellow ochre,
Viridian,	Brilliant ultramarine,	Purple madder,
Brown madder,	Caledonian brown,	Raw umber,

For all the varied hues to be met with among flowers it is necessary to have an extensive palette. I have, therefore, included all the pigments selected for the palette for general use in the one given above. In the case of fruit some warm and brilliant colors will be required, and if arranged with its accompanying leaves, the various greens of foliage will be required. It would be manifestly impossible to give the composition of tints for the various objects which might be represented under this head. The individual specimens of the same kind also vary so much in color that tints composed for one would not answer for another. Yet we may mention certain combinations which could be used for some of the members of this class most commonly represented, which may be useful as suggestions of possible combinations.

The color of red grapes may be made with Indian red, yel-

low ochre and white with a little black. The bloom on the
surface with Indian red, black and white. Black grapes
may be painted with black, white and a little burnt Sienna.
Apples will require various tints of red, yellow and green,
such as vermilion, orient yellow and burnt Sienna with
white. And white, orient yellow and a little ultramarine
for the greenish side, or for a deep red, brown madder,
vermilion, or vermilion and burnt Sienna. Oranges may be
painted with cadmium yellow and white with cadmium red
and black in the shadows, and lemons with orient yellow
and white, with, perhaps, a touch of cadmium red in the
shadows. Peaches will require cadmium yellow and white,
with a little vermilion, while in the deepest shadows yellow
ochre may be substituted for cadmium and madder brown
for vermilion. For the bloom, a warm grey made from
the yellow, red, white and black used in making the other
tints.

In painting flowers, where such varied tints are required,
it seems especially useless to attempt to make suggestions
as to the selection of colors for any particular combinations,
but a few hints as to certain general types may, however, be
of use. For scarlet flowers, the painter must be contented
with the tints formed from vermilion, or rose madder with

ellow, as bright scarlet and scarlet lake have been ban-
shed from our palette. The tints furnished by vermilion,
lazed with rose madder or by deep cadmium, and rose
madder will, however, be sufficiently bright. Brown mad-
er or burnt Sienna with black may be used with the red
in the shadows. For pink flowers rose madder and white
an be used with vermilion and aureolin, or cadmium where
he tints incline to cherry or yellowish tones. Orange
lowers may be painted with cadmium red, cadmium red
and burnt Sienna, touched with brown madder in the deep-
st parts. Yellow flowers with orient yellow and white,
hadows orient yellow, burnt Sienna and black. Deep red
lowers, as the color of dark nasturtiums, Indian red, shad-
d with Indian red and burnt Sienna. Flowers which are
eally blue are very rare. The little Plumbago cœrulia is
ne of the very few which may be said to be really of this
olor. The tints of most flowers, nominally of this hue,
vould require an admixture of yellow with the blue used
n making the tint, while many incline to purple. Purple
lowers may be represented by various tints made from
ose madder with ultramarine and white, or purple madder
vith brown madder or blue black in the shadows.

We will close these suggestions, however, well convinced

of the futility of trying to impart any information upon the subject, except that of the most general character. The question is not one which can be reduced to a mathematical calculation, and where combinations can be varied to the extent which is possible in the mixing of pigments, and the result is in so great a degree dependent upon the individual taste and feeling of the painter, it is impossible to give special directions.

APPENDIX.

PIGMENTS TO BE AVOIDED.

Silver white,
Flake white,
Cremnitz white,
Lemon cadmium,
Citron yellow,
Mutrie yellow,
Indian yellow,
Italian pink,
Quercitron lake,
Orpiment,
Carmine,
Crimson lake,
Scarlet lake,
Purple lake,
Florentine lake,
Chinese lake,
Roman lake,
Venetian lake,
Dragon's blood,
Indian lake,
Pure scarlet,
Red chrome,

Smalt,
Red lead,
Antimony red,
Cyanine blue, (semi-stable),
Indigo,
Intense blue,
 (more durable than indigo),
Antwerp blue,
Chinese orange,
Chrome orange,
Antimony orange,
Malachite green,
Vertigris,
Bronze,
Hooker's green,
Prussian green,
Sap green,
 or *vert de vessie.*
Burnt lake,
Indian purple,
Violet Carmine,
Olive green.

VARIOUS NAMES UNDER WHICH CERTAIN PIGMENTS ARE KNOWN.

Viridian is also called Paul Veronese green and Permanent green.

Ultramarine—Outremer, Lazuline, Lazuline blue, Lazulite, Lazurstein, Azure.

Artificial ultramarine — Brilliant ultramarine, Metz, Gmelin's blue, or factitious ultramarine, *bleu de Garance*, *Outremer de Guimet*, French ultramarine, New blue and Permanent blue.

Vermilion—Cinnabar.

Cadmium—*Jaune brilliante.*

Blue black—Liege black, Vine black.

Purple madder—Purple rubiate, Field's purple, Field's russet.

VARNISHING.

After an oil painting becomes dry it is necessary that some preparation in the nature of varnish should be applied to bring out the colors and give them their proper effect. The question of varnish is one, however, that it is

very difficult to solve in a satisfactory manner, and a matter which has led to the ruin of many paintings.

A heavy coating of varnish is neither desirable for the artistic effect nor for the preservation of the picture. Whatever varnish is applied, therefore, must be laid on with care, and not too thickly. The painting must, however, be allowed to become thoroughly dry before it is permanently varnished, otherwise the varnish will crack. The time that should elapse before a picture may be considered in condition for the application of varnish is variously estimated, and it is considered that even six months is not a longer time than is necessary to render the process free from danger.

In the meantime something must be used to serve the purposes of a varnish. For this nothing is better than Soehnée Fréres' retouching varnish. This preparation is said to be free from objectionable qualities, can be used at once, and will last for a year or so. After a sufficient time has elapsed to ensure the complete drying of the picture a good permanent varnish can be used or the retouching varnish can be re-applied.

INDEX.

We prepare

A SPECIAL SET OF OIL COLORS

as called for by

« MISS McLAUGHLIN »

in this Book

and sell it at a SPECIAL PRICE.

❋ NEW CATALOGUE. ❋

We published, Dec. 1887, a new General
Catalogue, comprising

OIL AND WATER COLORS, PASTELS,
LUSTRE PAINTS, TAPESTRY COLORS,
MODELING MATERIALS, DRAWING
INSTRUMENTS, CARVING TOOLS, ETC.

Mailed for 10 cents or FREE if you mention this Book.

EMERY H. BARTON, ⊹ 171 RACE STREET,
CINCINNATI, OHIO.

CPSIA information can be obtained
at www.ICGtesting.com
Printed in the USA
BVHW04*1133050918
526586BV00014B/165/P